William Shakespeare

AN ADULT COLORING BOOK

BY ODESSA BEGAY

LARK
New York

Introduction

The more Shakespeare I read, the more I realize his work is alive and well today, even 400 years after his last play. From the modern retellings that still bear their original titles and characters to the countless modern stories that revolve around themes and plots he pioneered, Shakespeare's work is all around us. The same betrayals, double crossings, mistaken identities, love triangles, and mysteries that thrilled audiences at the Globe abound in modern plays, movies, and books.

But it's not just in works of narrative that Shakespeare's legacy is felt. He also finds his way into everyday conversations. Many of our most commonly used phrases originated from the works of William Shakespeare. Just to name a few:

"Forever and a day"—*As You Like It*
"You can't have too much of a good thing."—*As You Like It*
"You've got to be cruel to be kind."—*Hamlet*
"In my heart of hearts"—*Hamlet*
"Full circle"—*King Lear*
"Knock knock! Who's there?"—*Macbeth*
"Be all and end all"—*Macbeth*
"As luck would have it"—*The Merry Wives of Windsor*
"Laughing stock"—*The Merry Wives of Windsor*
"Fancy-free"—*A Midsummer Night's Dream*
"Wear my heart upon my sleeve"—*Othello*
"Foregone conclusion"—*Othello*
"Wild goose chase"—*Romeo and Juliet*
"Break the ice"—*The Taming of the Shrew*
"Kill with kindness"—*The Taming of the Shrew*
"Brave new world"—*The Tempest*

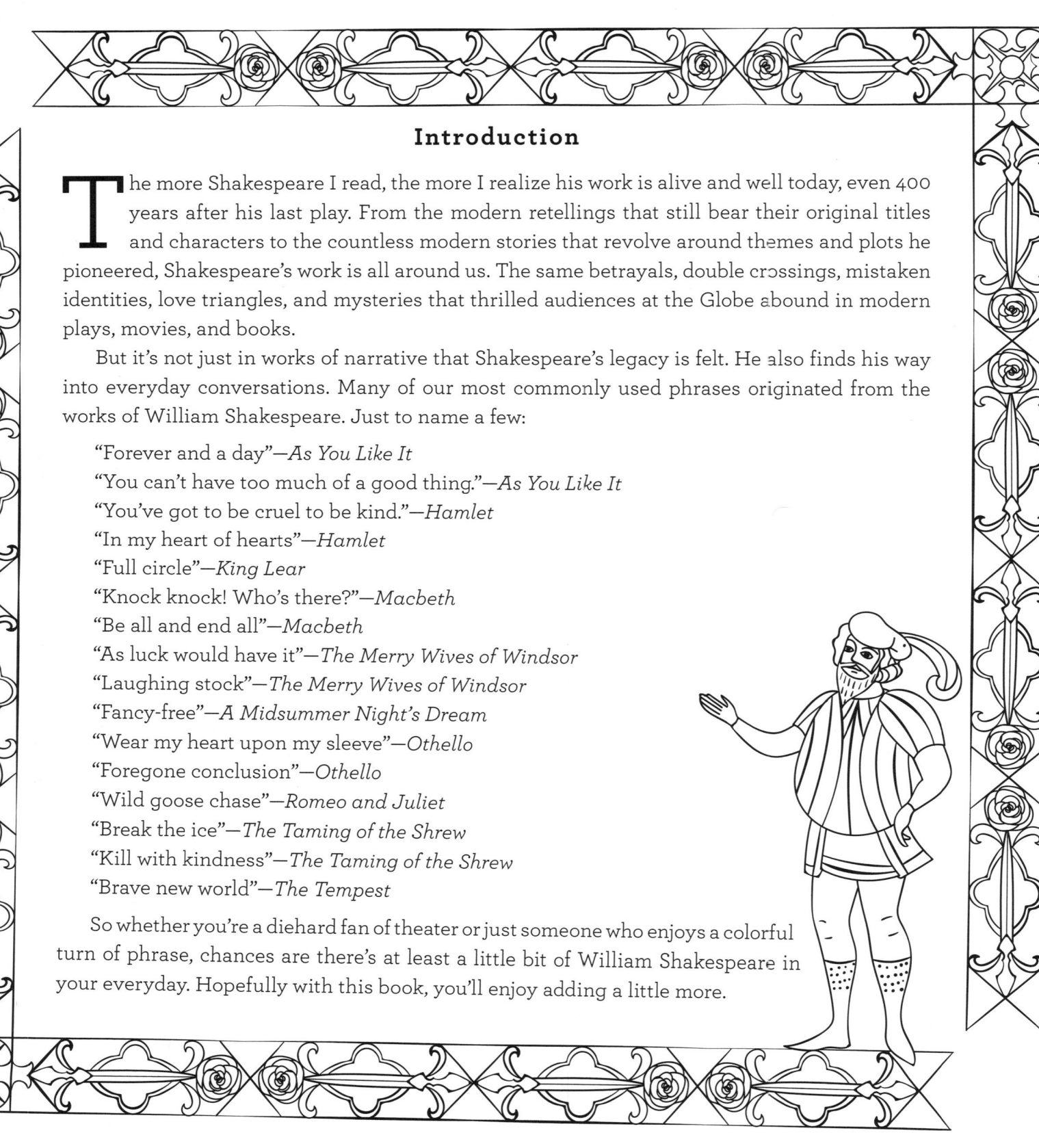

So whether you're a diehard fan of theater or just someone who enjoys a colorful turn of phrase, chances are there's at least a little bit of William Shakespeare in your everyday. Hopefully with this book, you'll enjoy adding a little more.

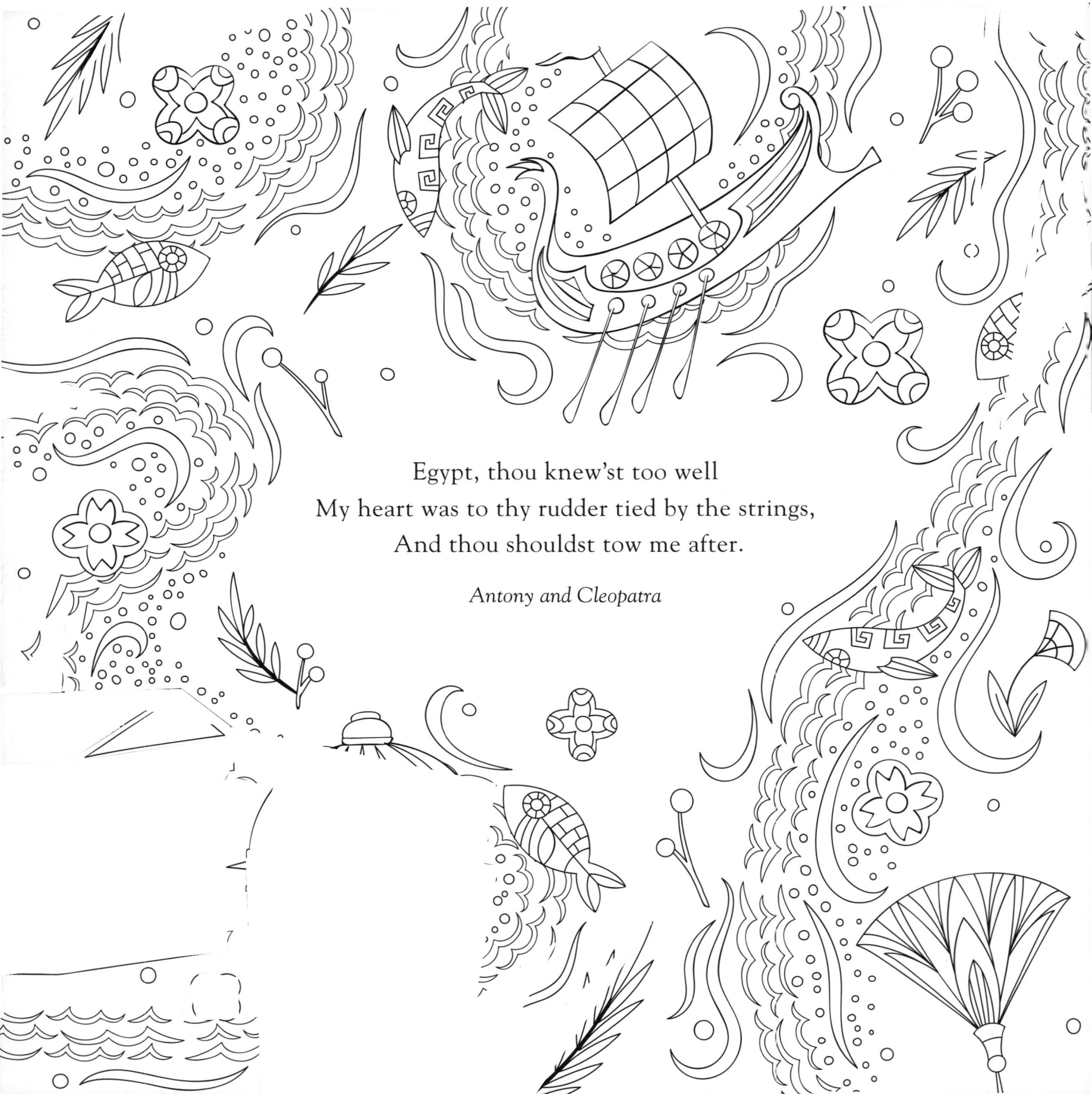

Egypt, thou knew'st too well
My heart was to thy rudder tied by the strings,
And thou shouldst tow me after.

Antony and Cleopatra

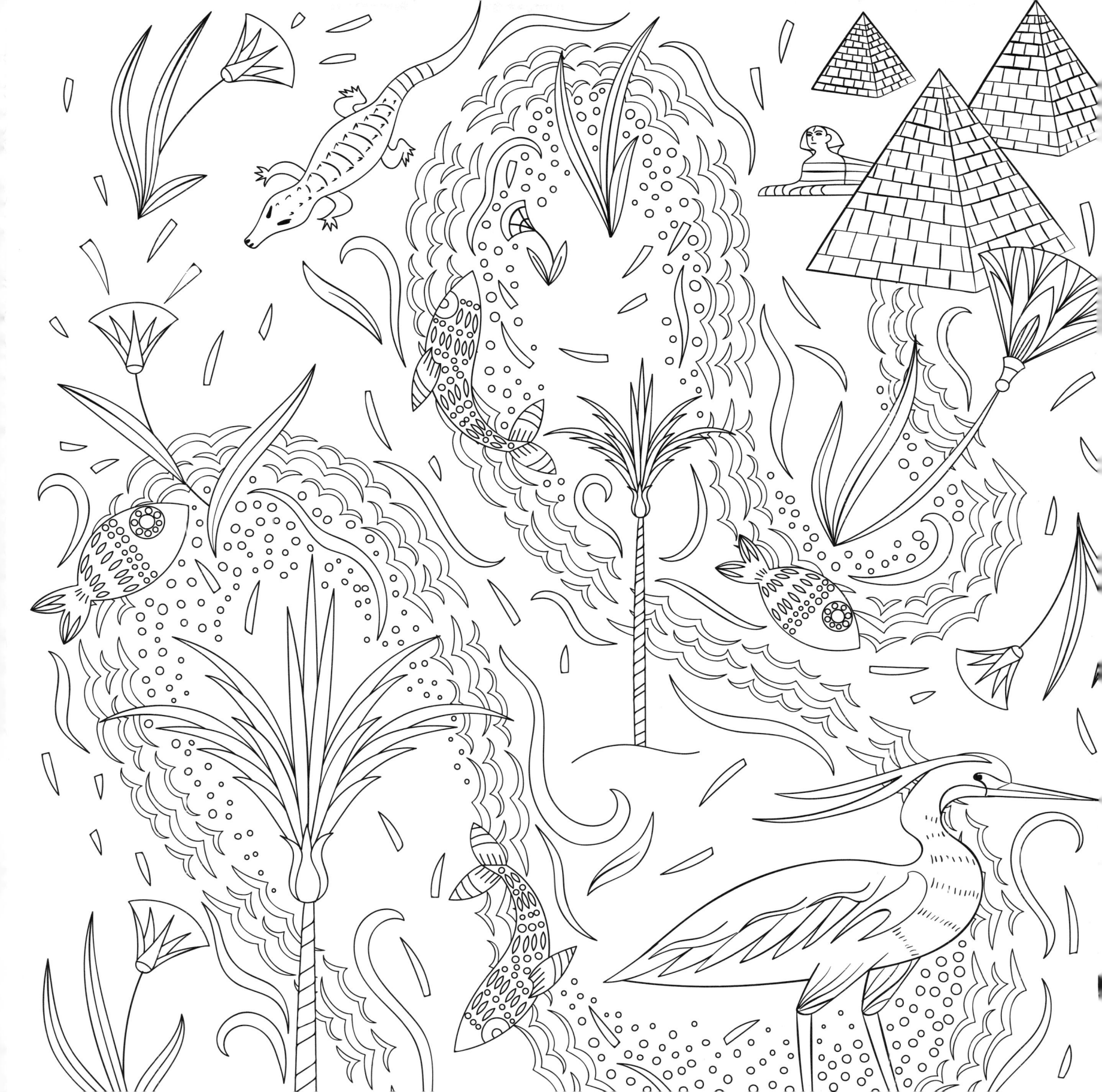

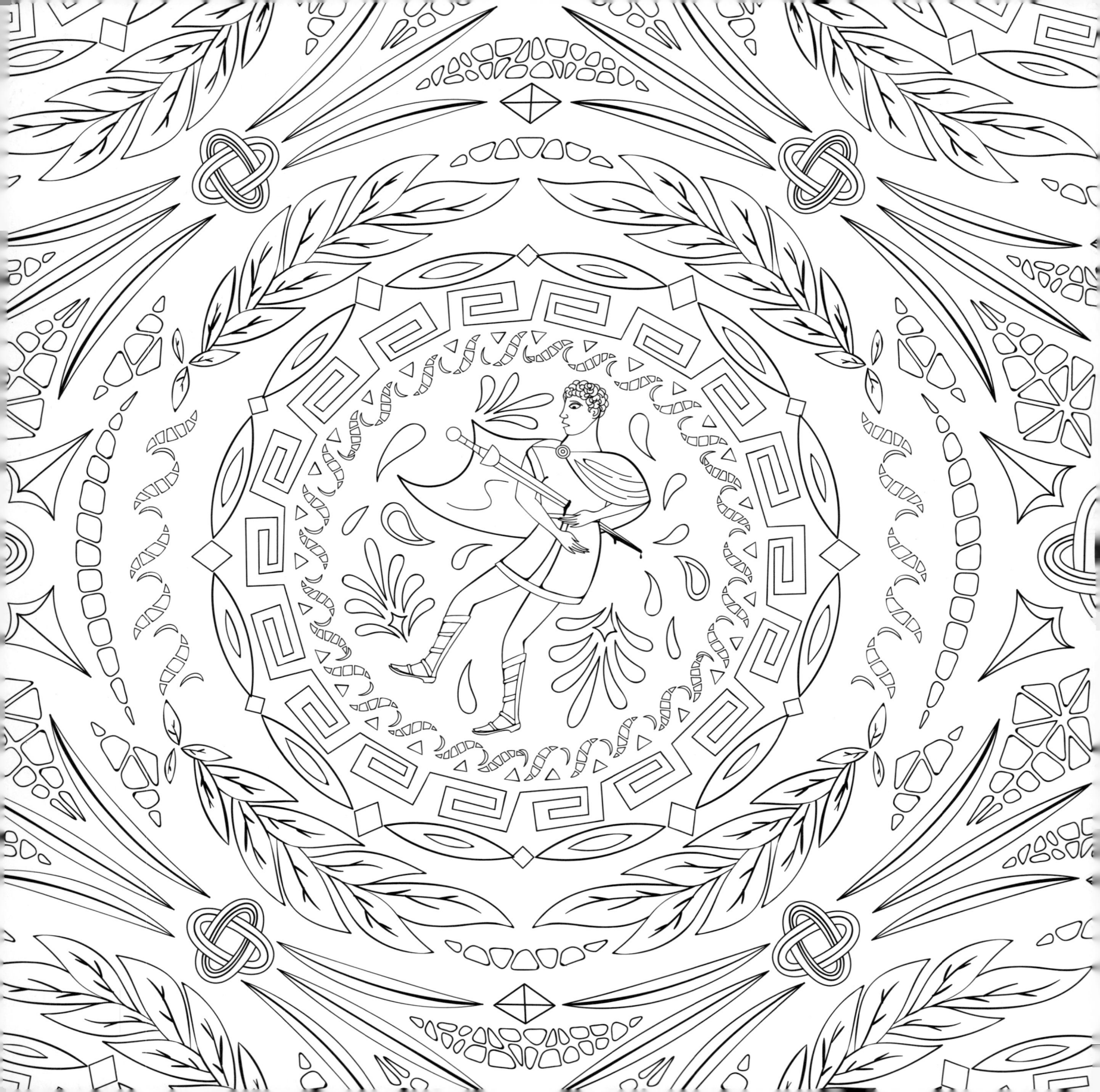

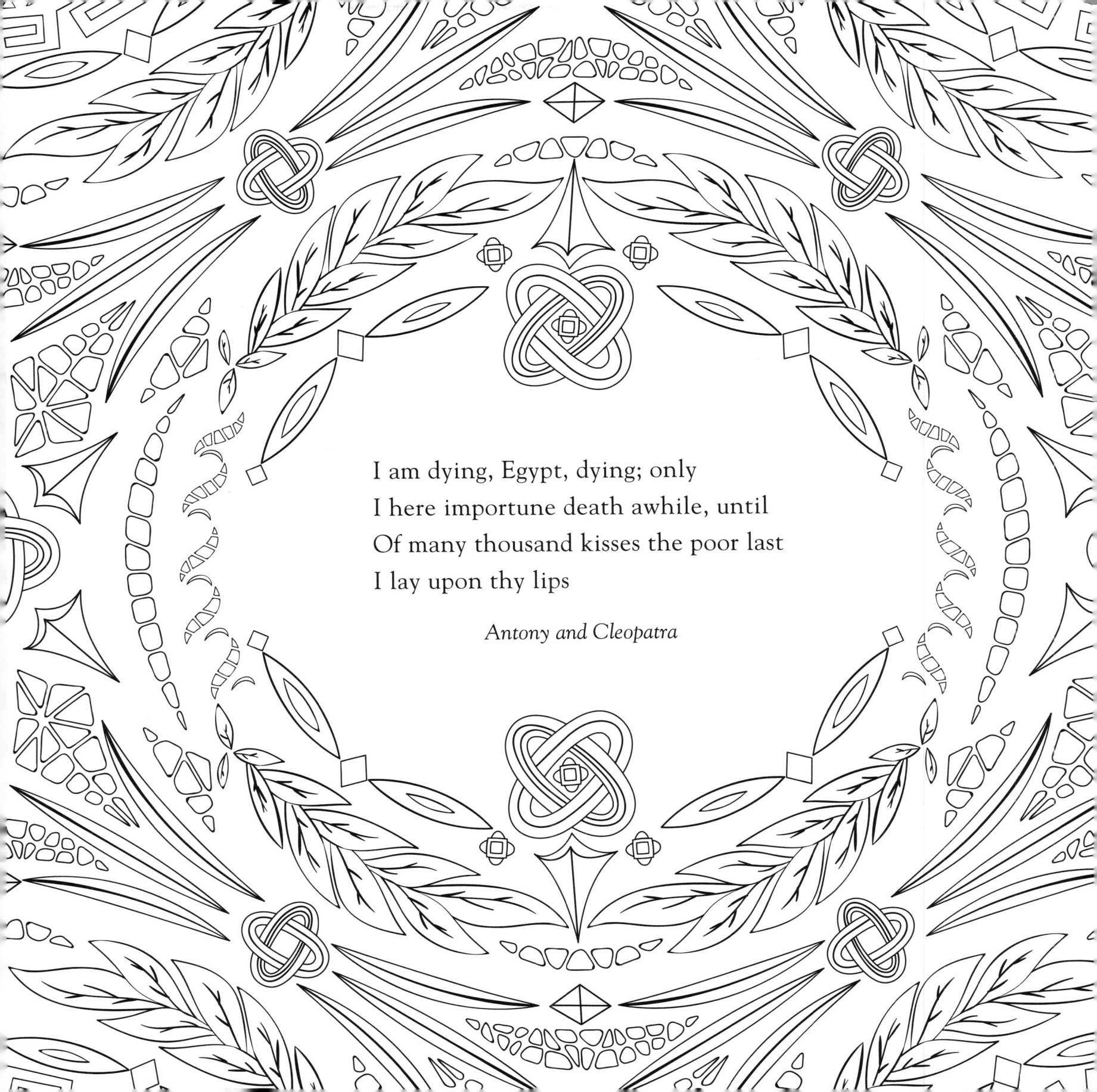

I am dying, Egypt, dying; only
I here importune death awhile, until
Of many thousand kisses the poor last
I lay upon thy lips

Antony and Cleopatra

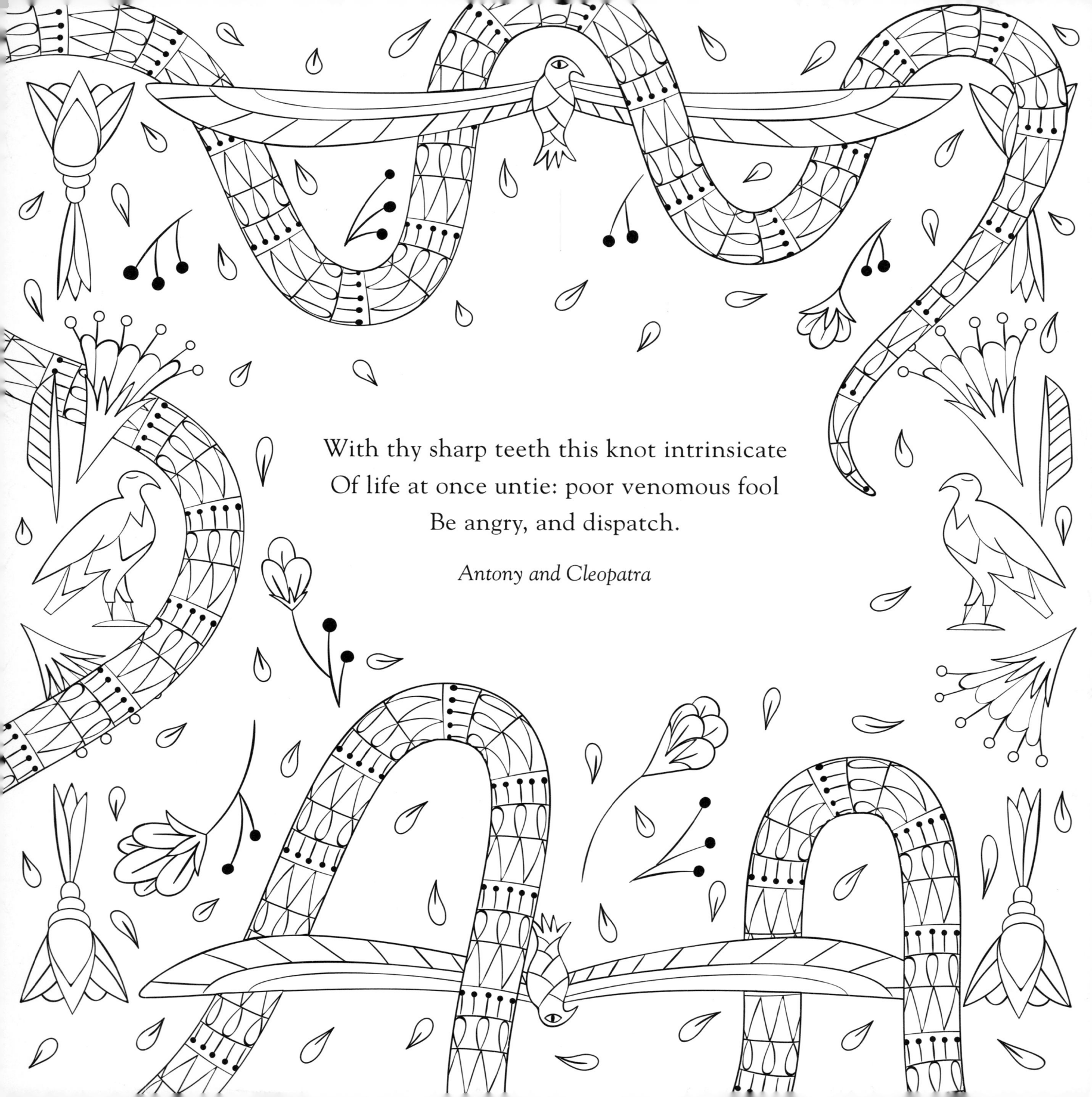

With thy sharp teeth this knot intrinsicate
Of life at once untie: poor venomous fool
Be angry, and dispatch.

Antony and Cleopatra

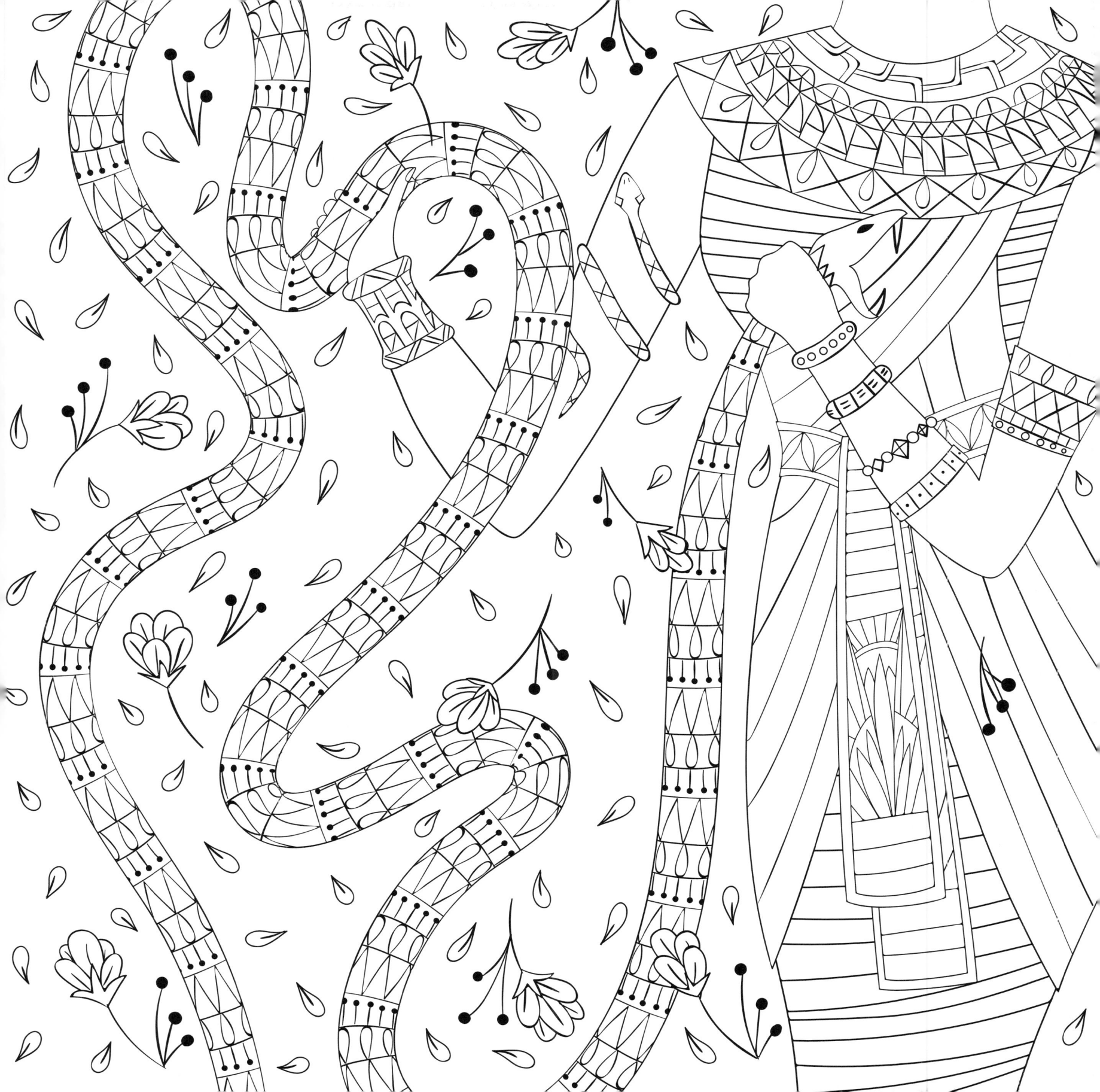

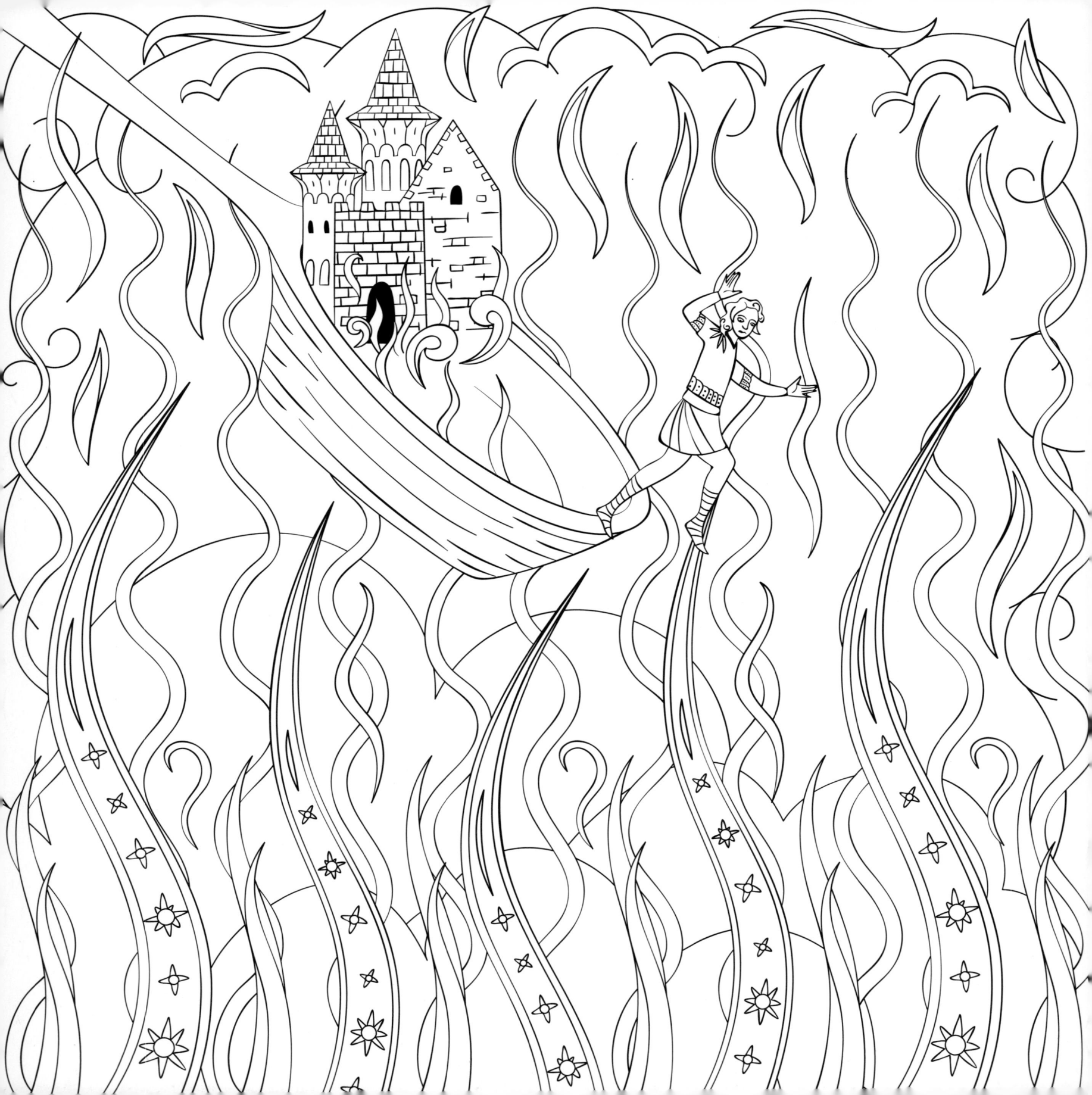

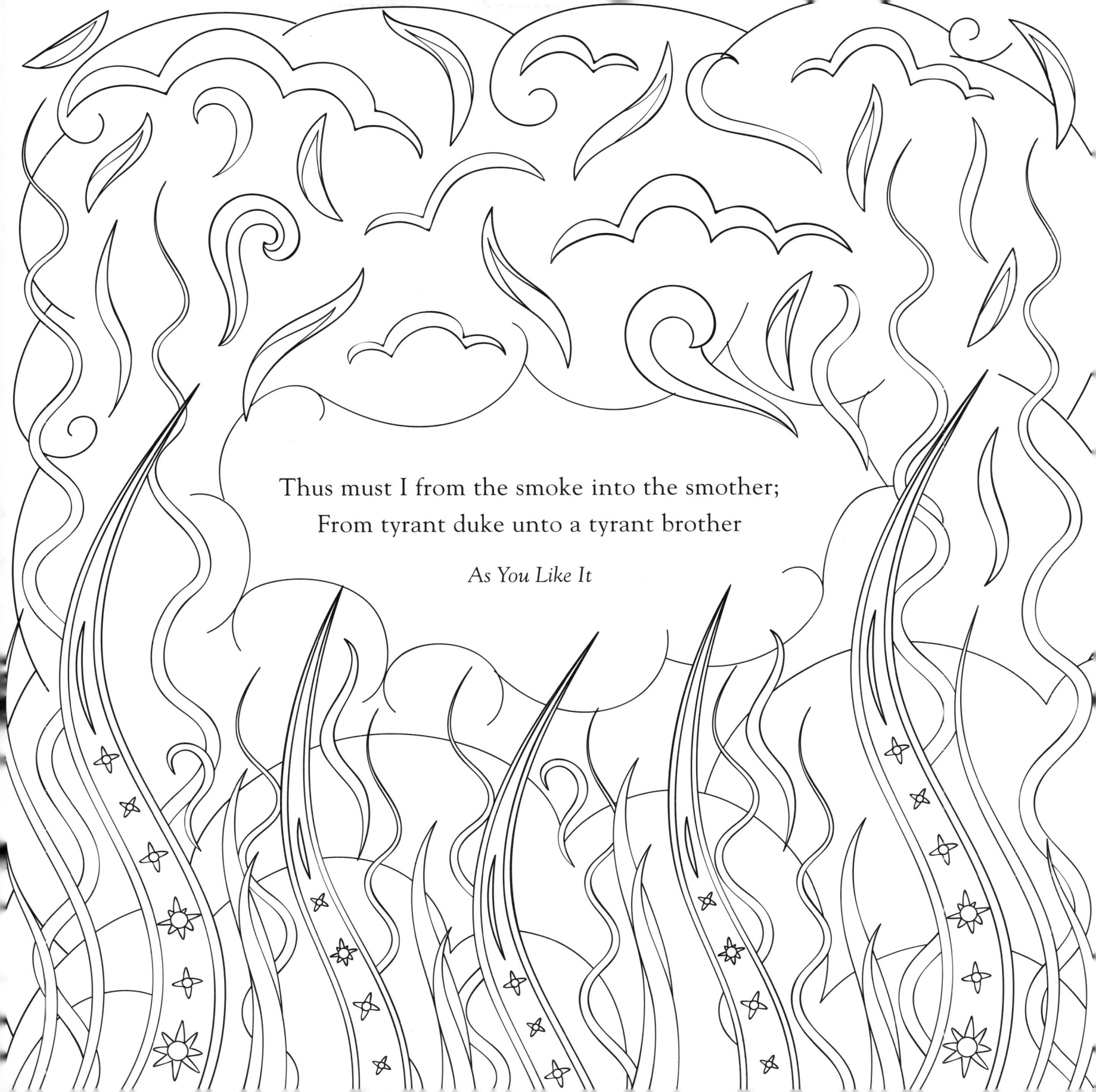

Thus must I from the smoke into the smother;
From tyrant duke unto a tyrant brother

As You Like It

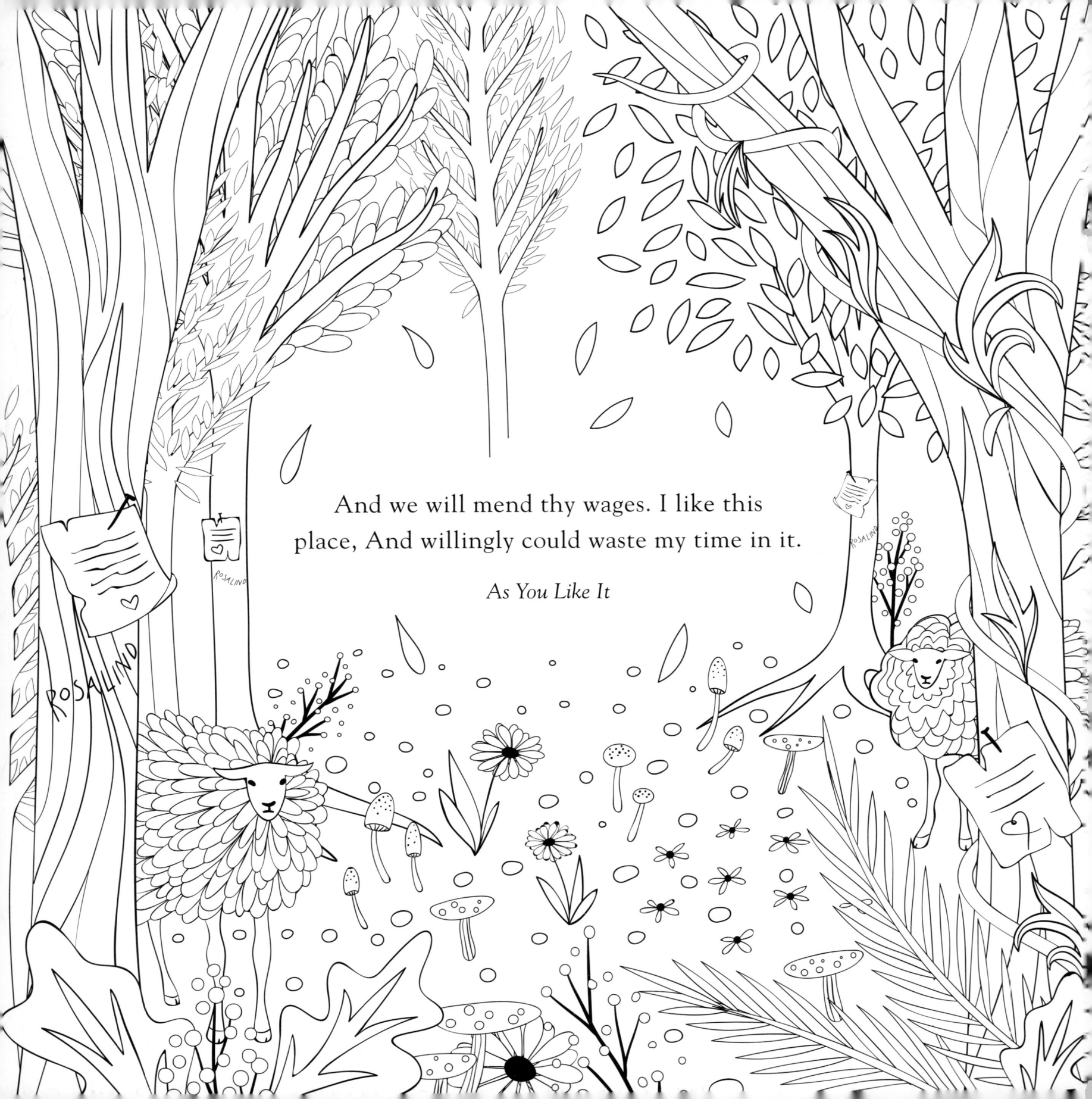

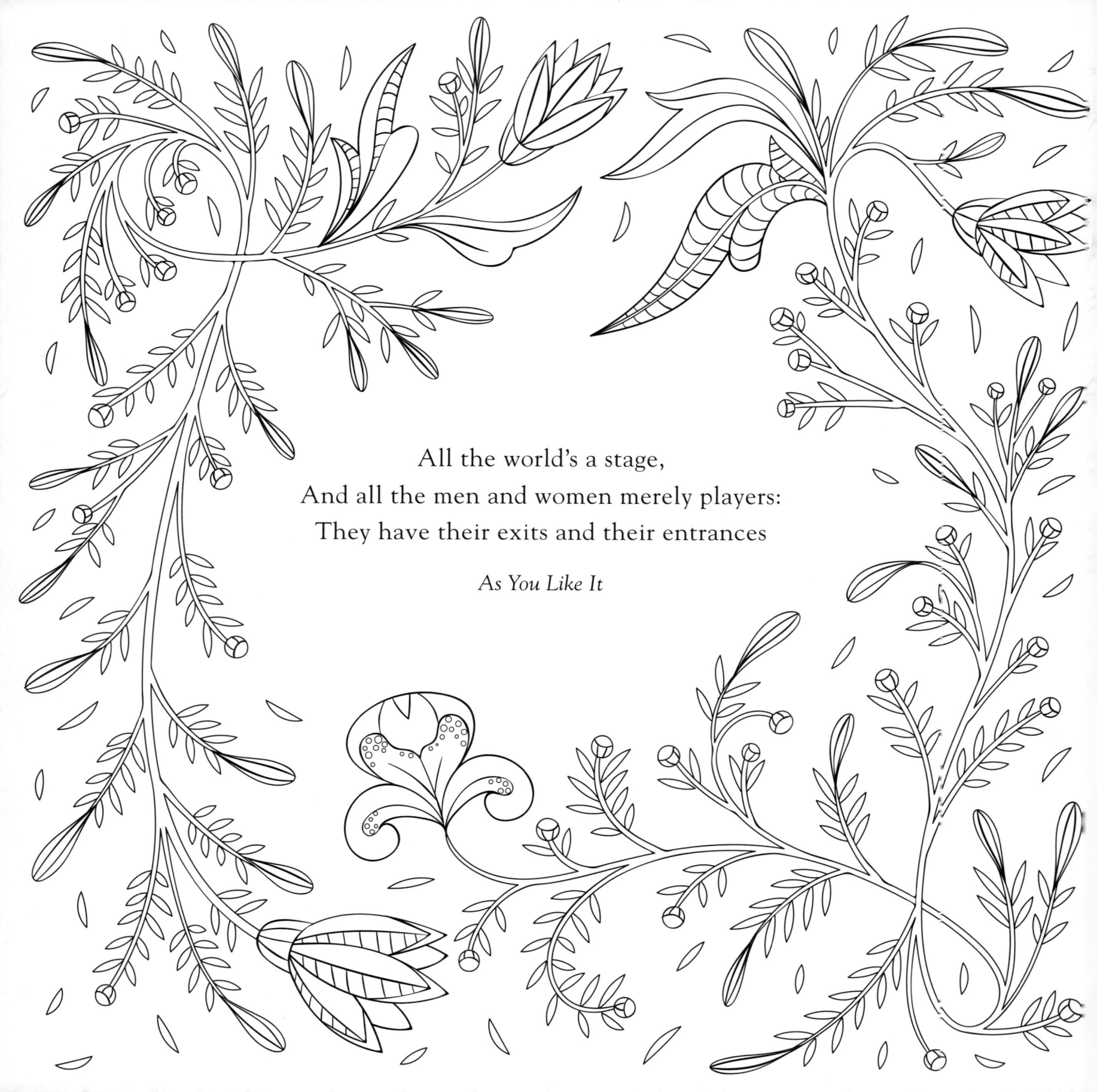

All the world's a stage,
And all the men and women merely players:
They have their exits and their entrances

As You Like It

Something is rotten in the state of Denmark.

Hamlet

Though this be madness, yet there is method in 't.

Hamlet

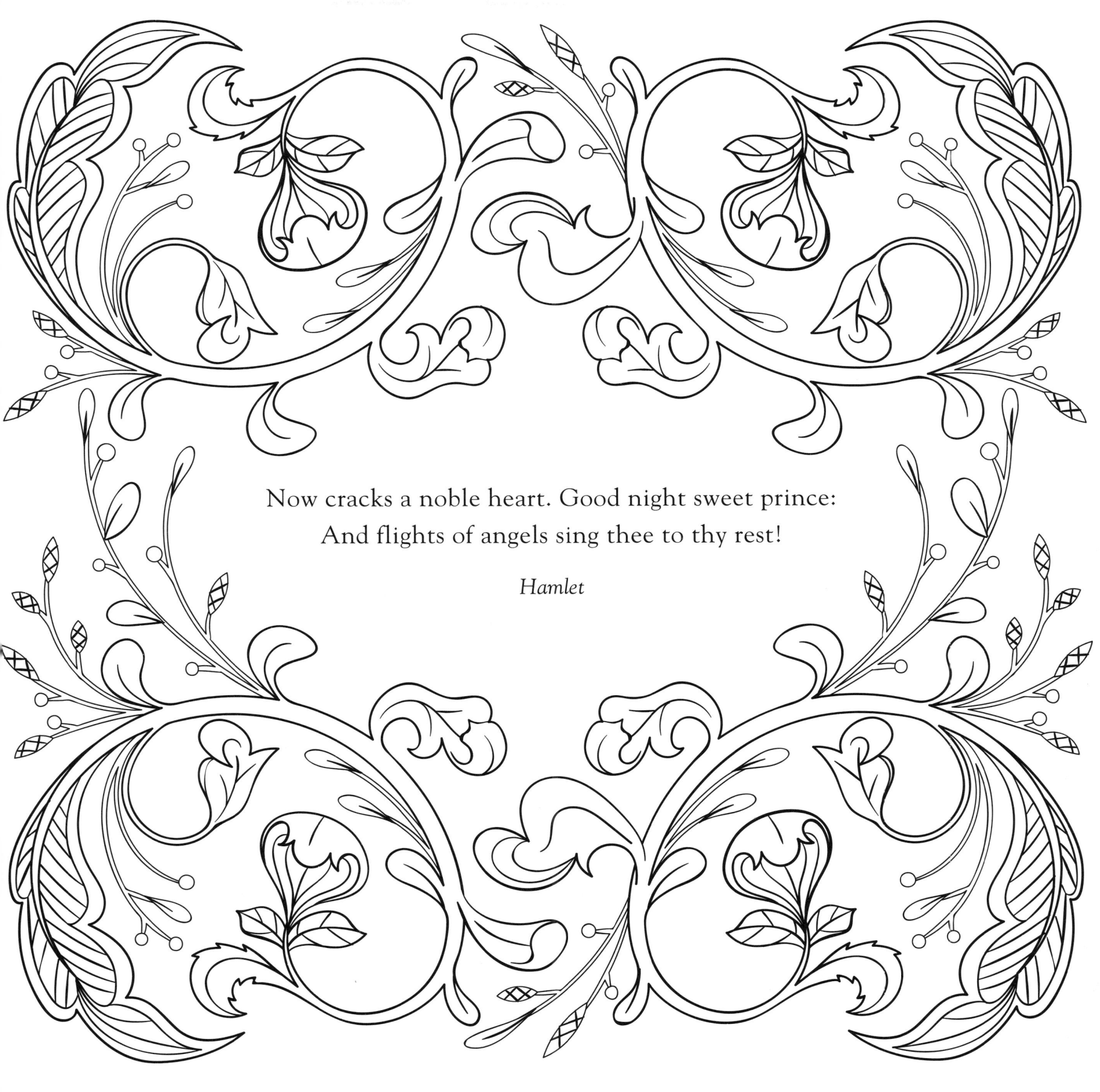

Now cracks a noble heart. Good night sweet prince:
And flights of angels sing thee to thy rest!

Hamlet

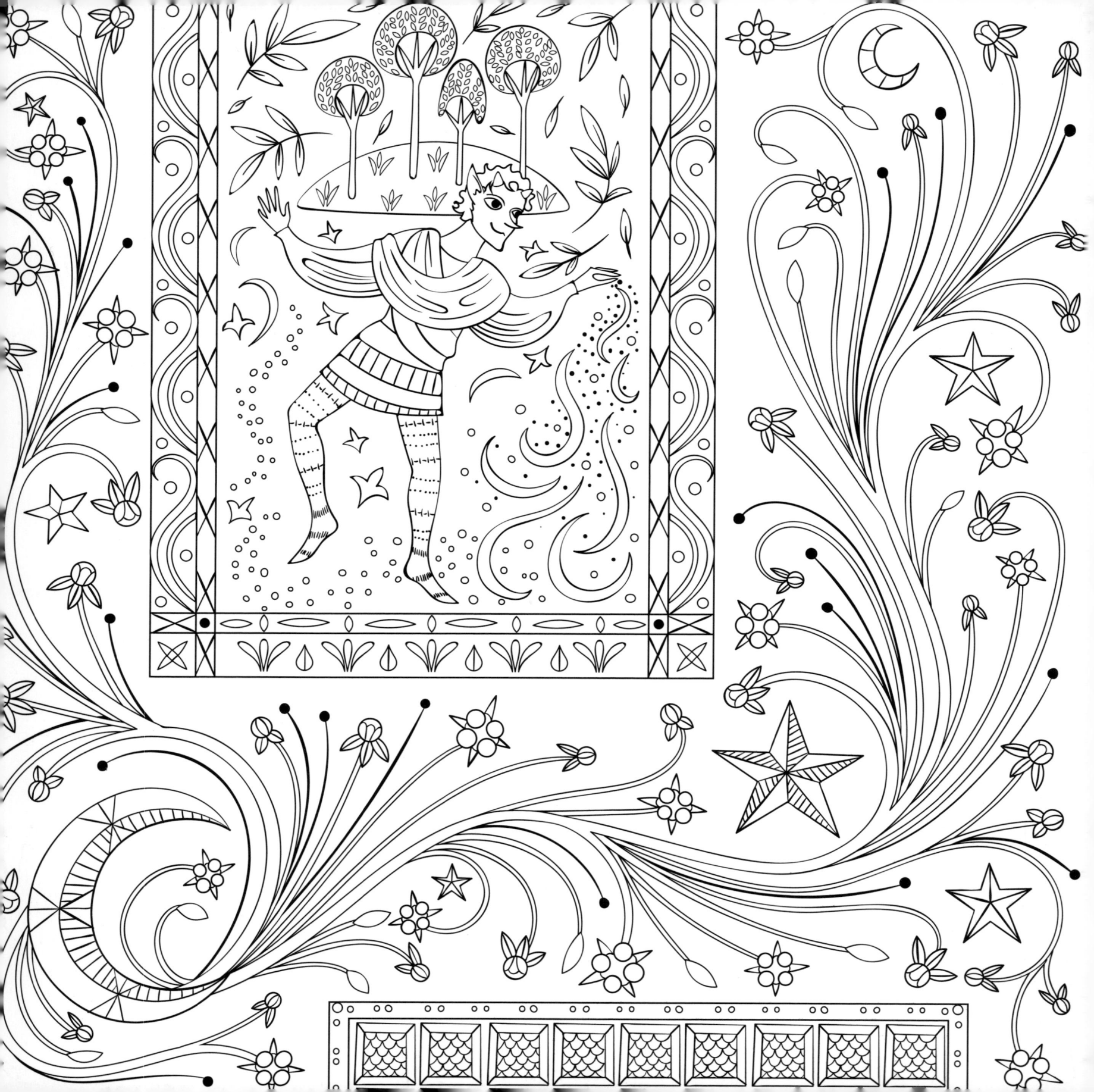

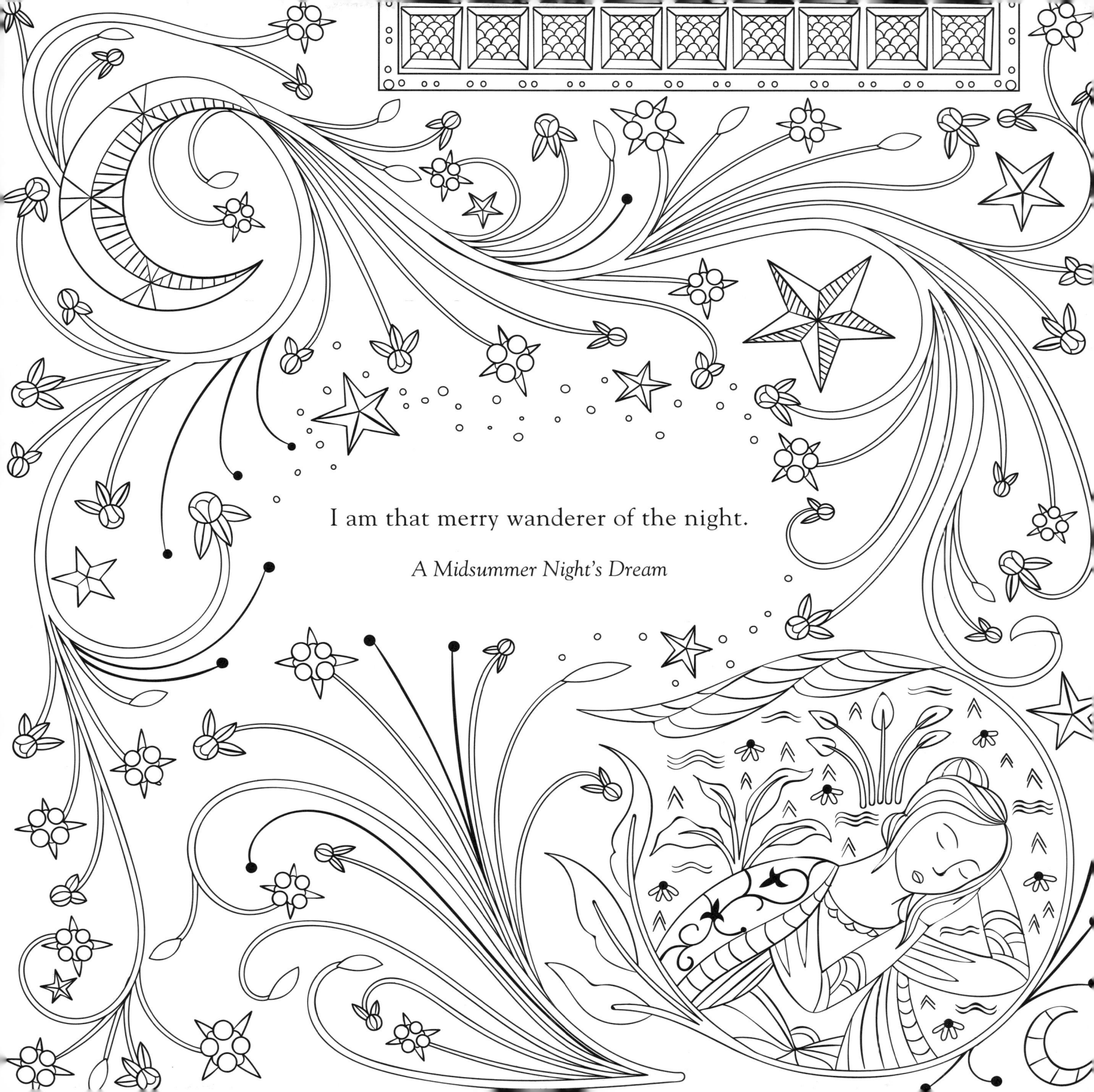

I am that merry wanderer of the night.

A Midsummer Night's Dream

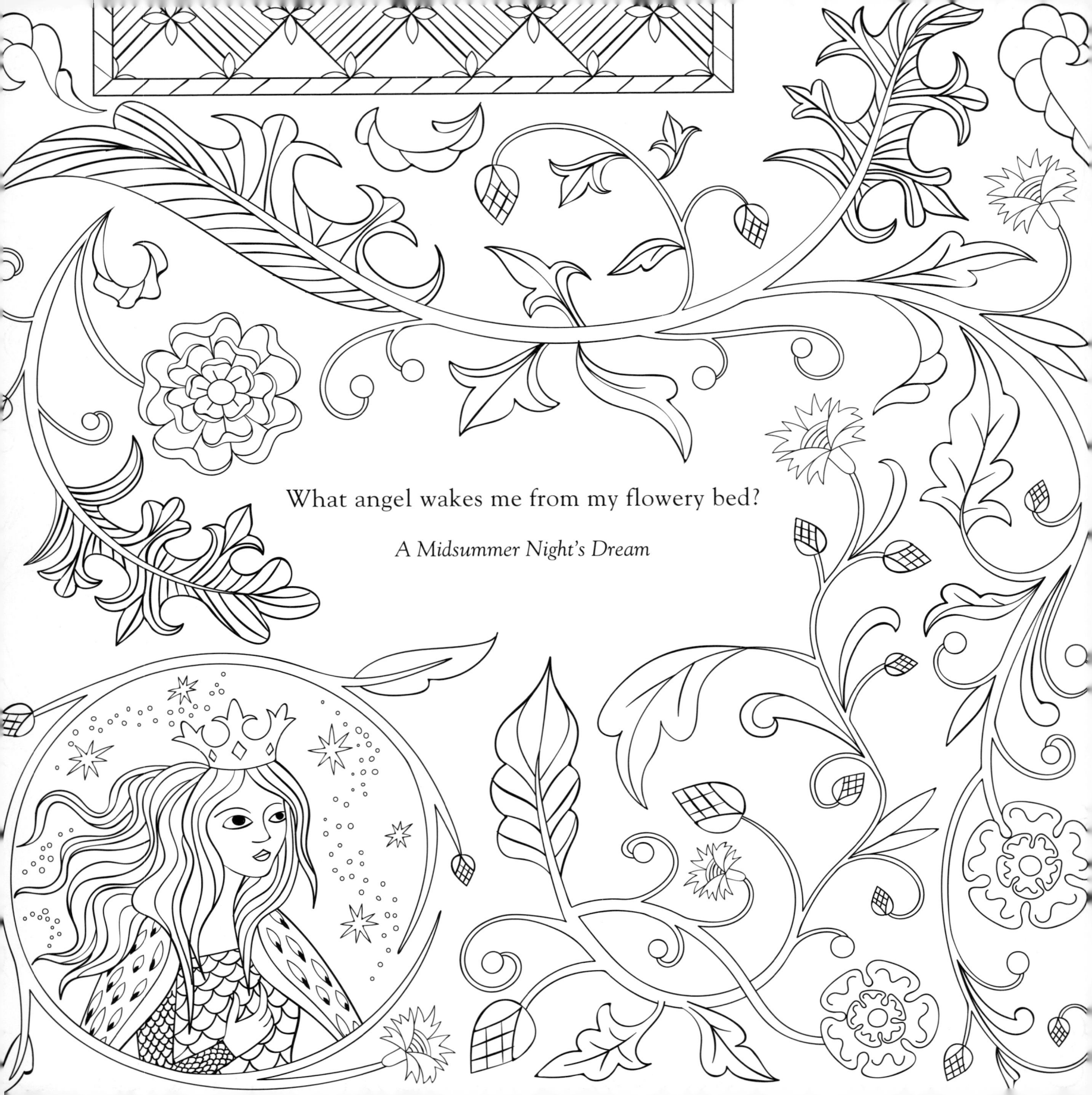

What angel wakes me from my flowery bed?

A Midsummer Night's Dream

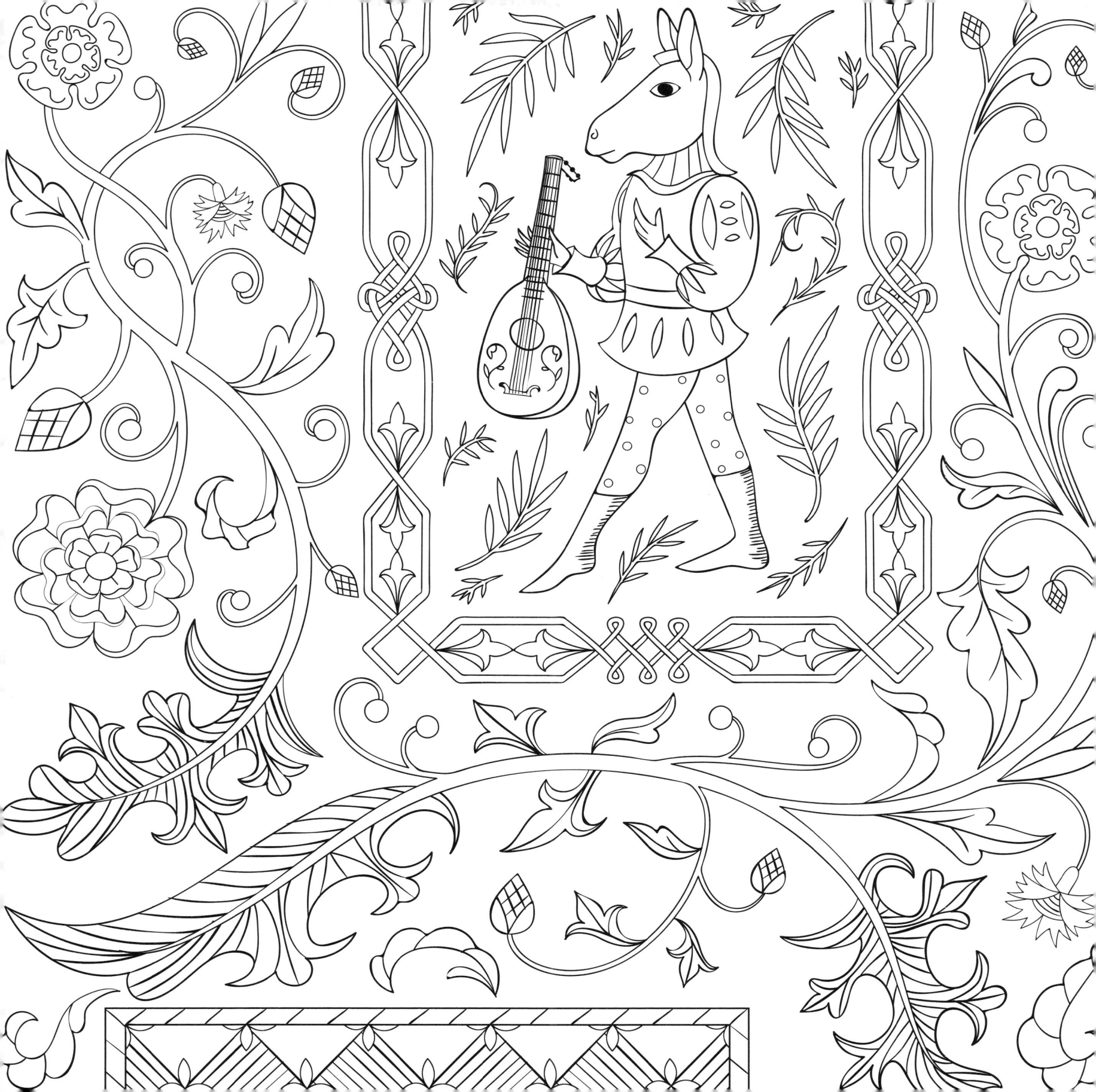

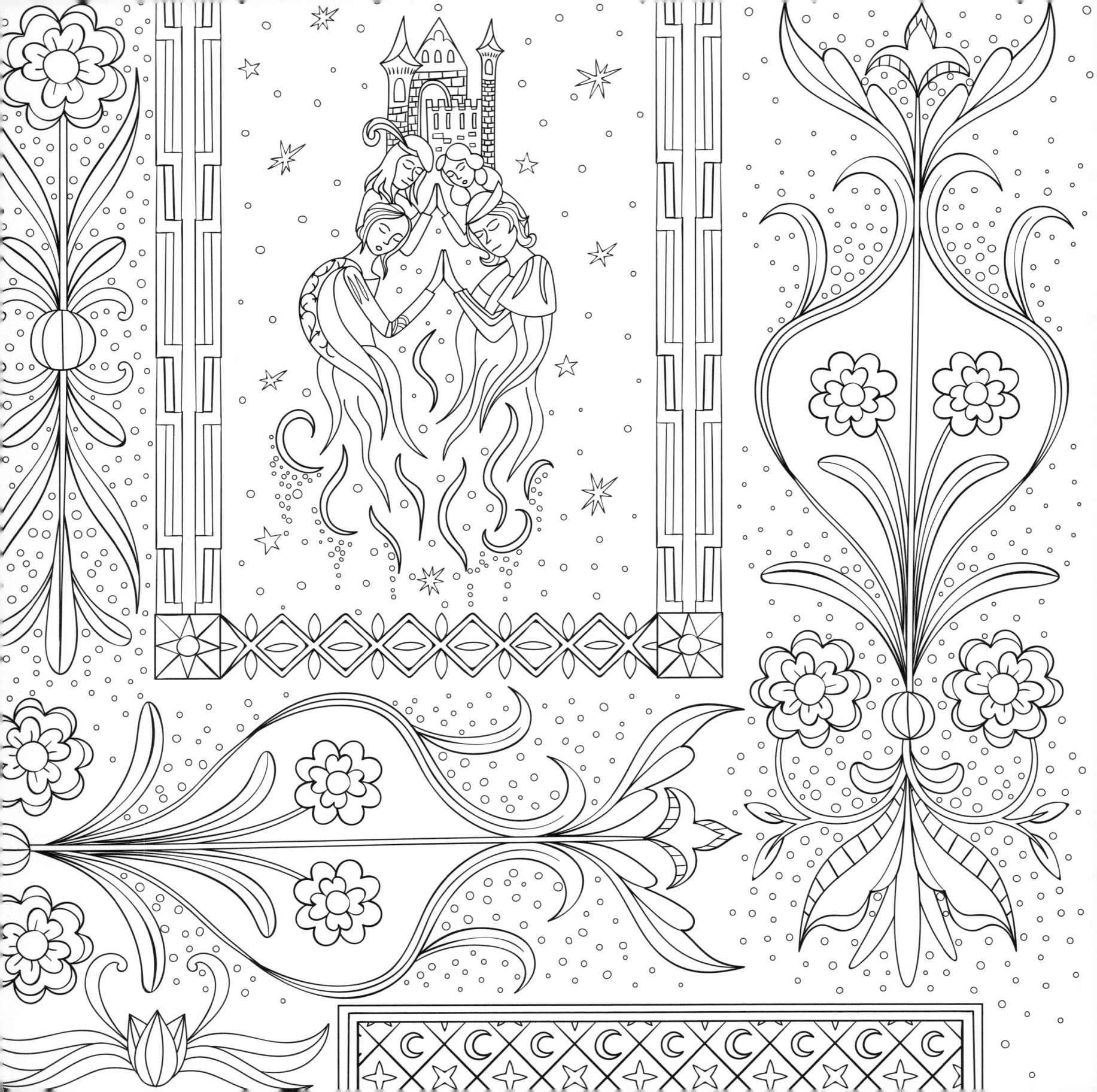

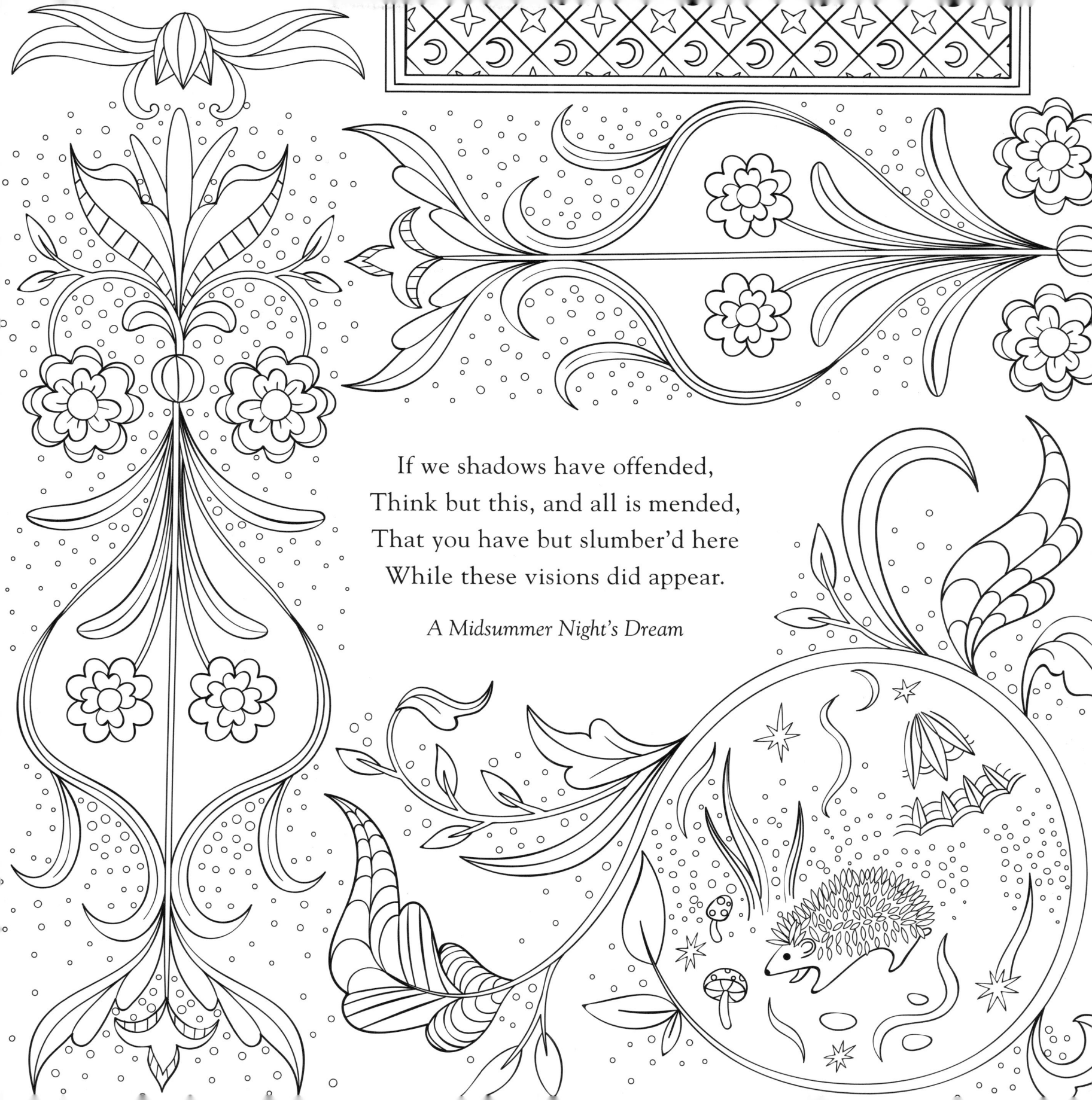

If we shadows have offended,
Think but this, and all is mended,
That you have but slumber'd here
While these visions did appear.

A Midsummer Night's Dream

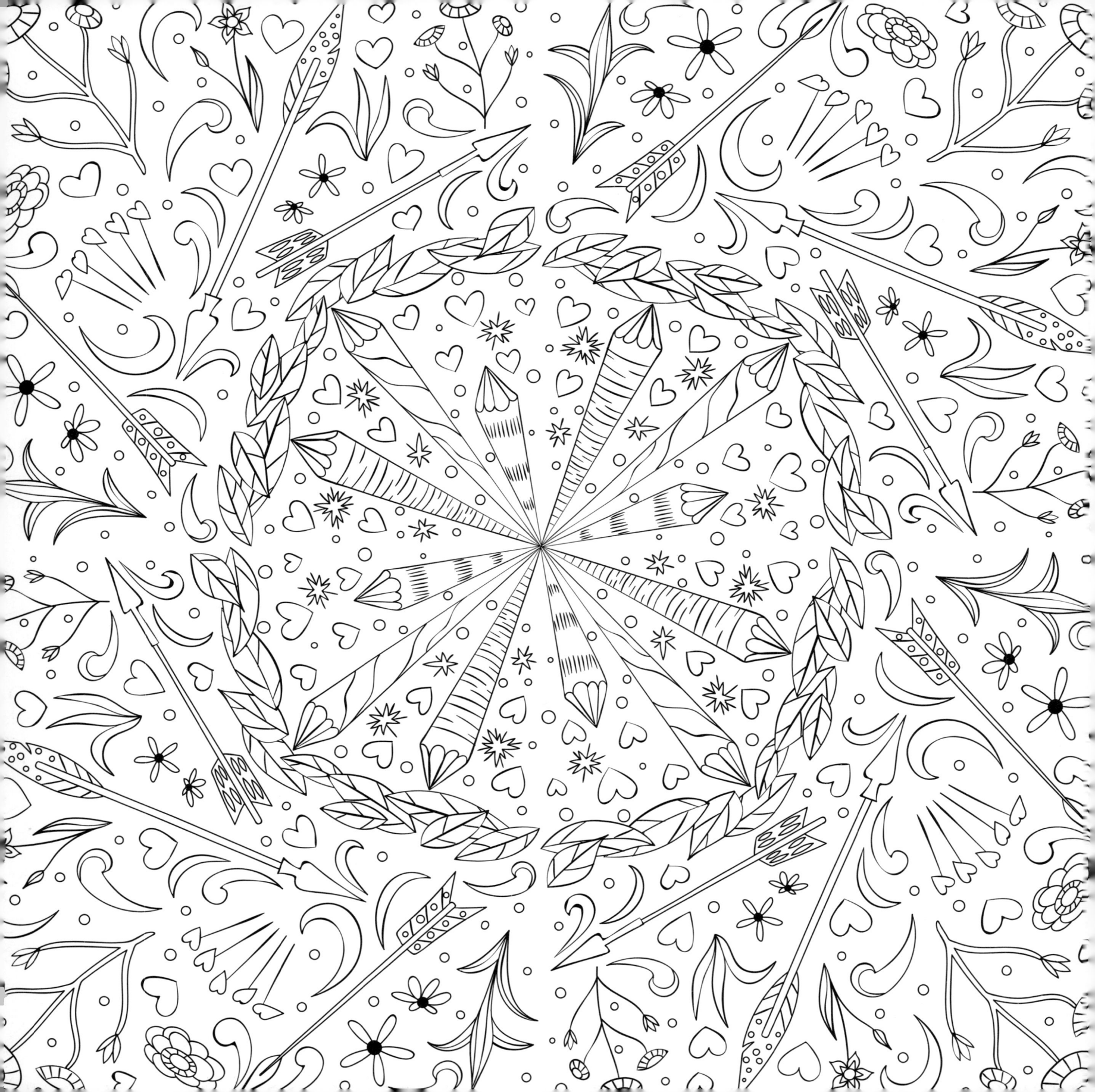

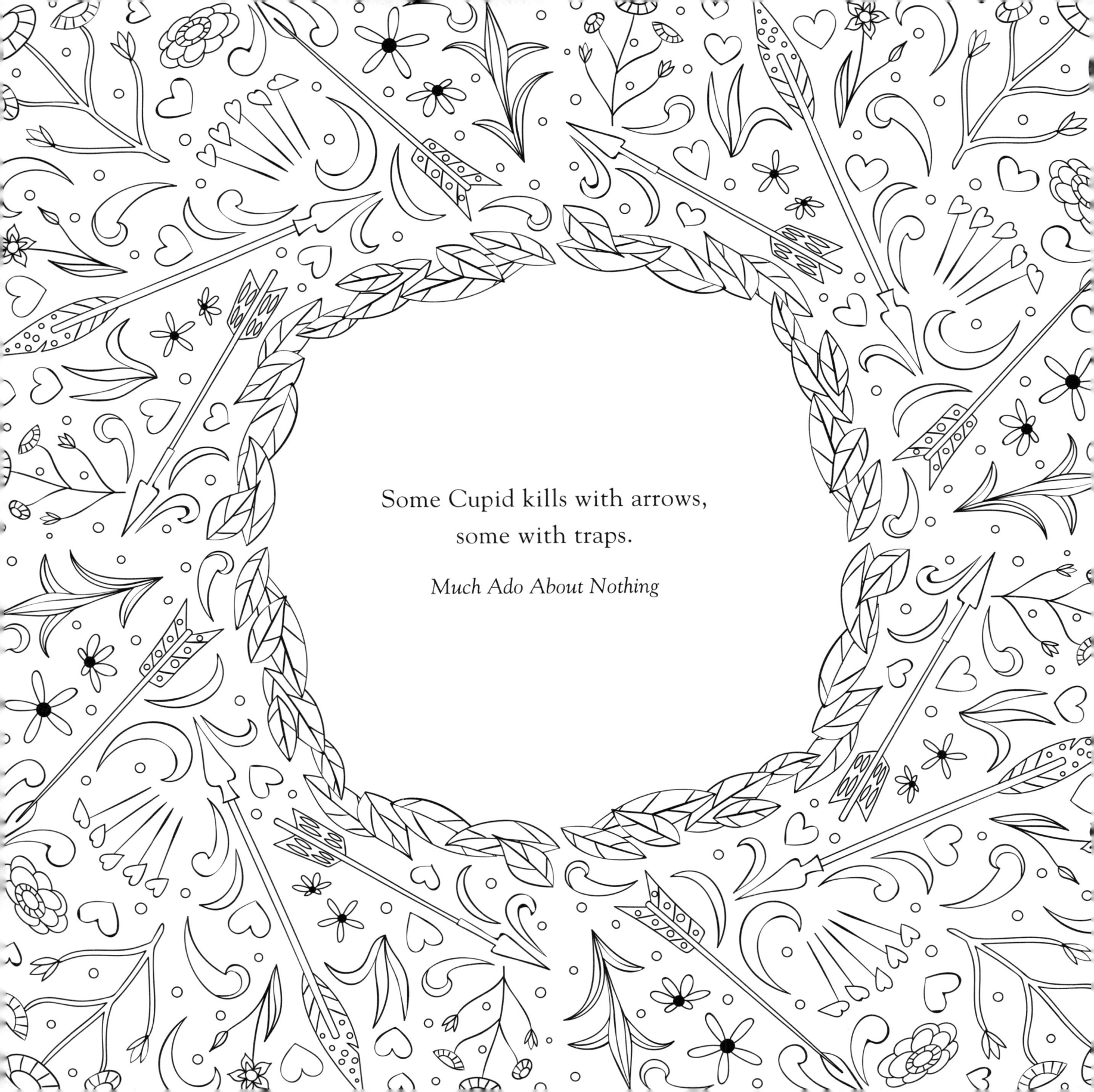

Some Cupid kills with arrows,
some with traps.

Much Ado About Nothing

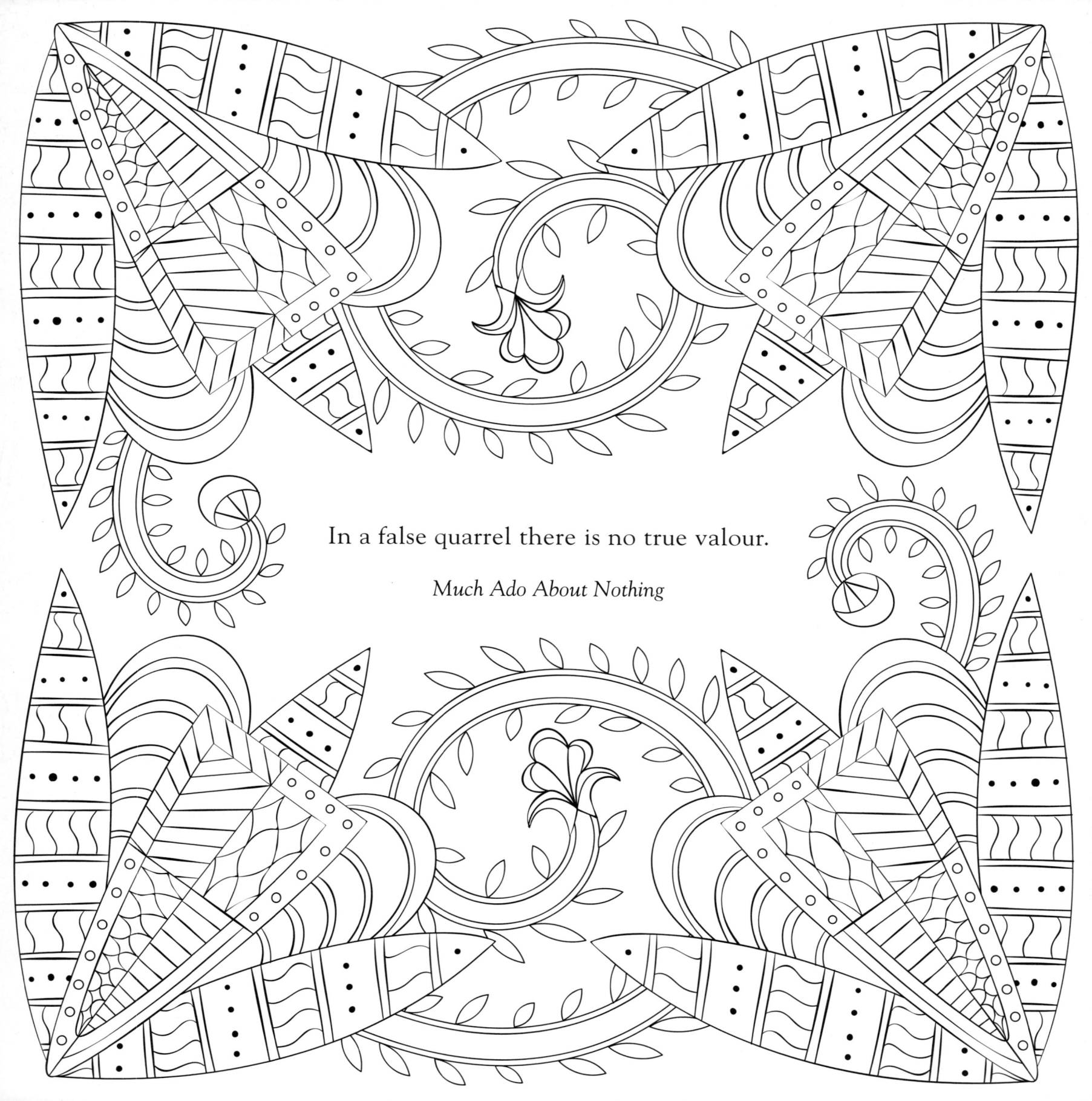

In a false quarrel there is no true valour.

Much Ado About Nothing

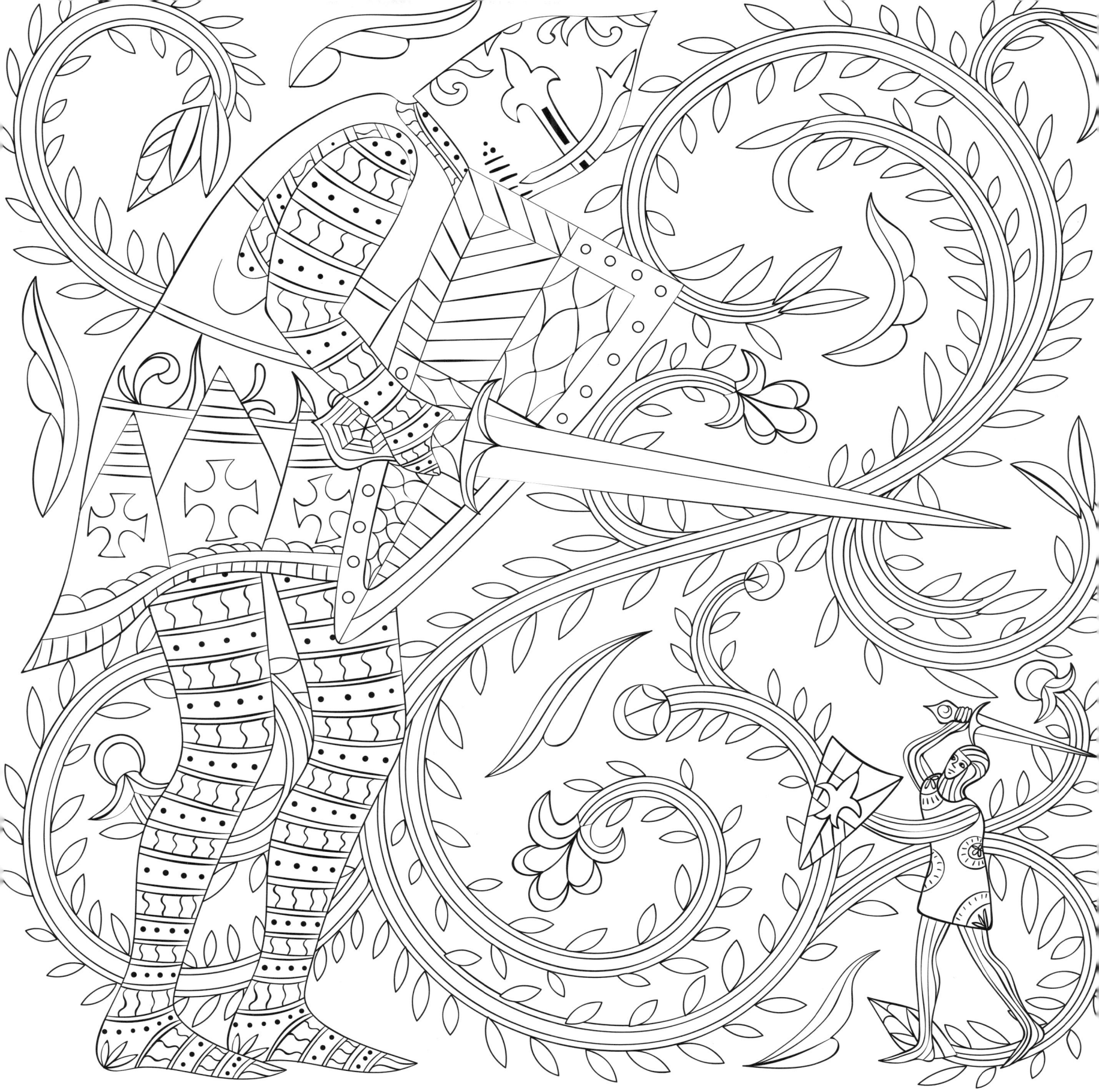

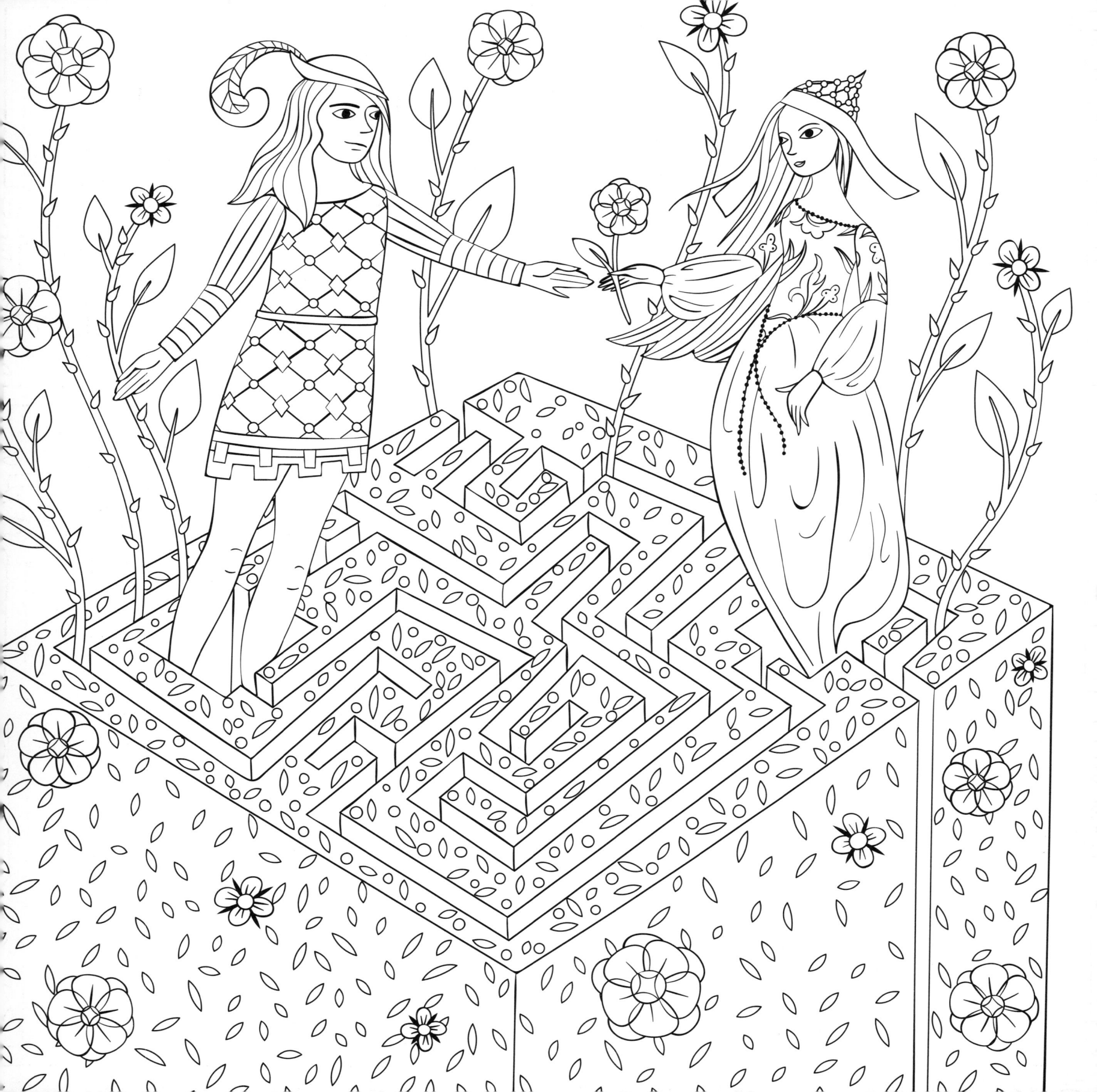

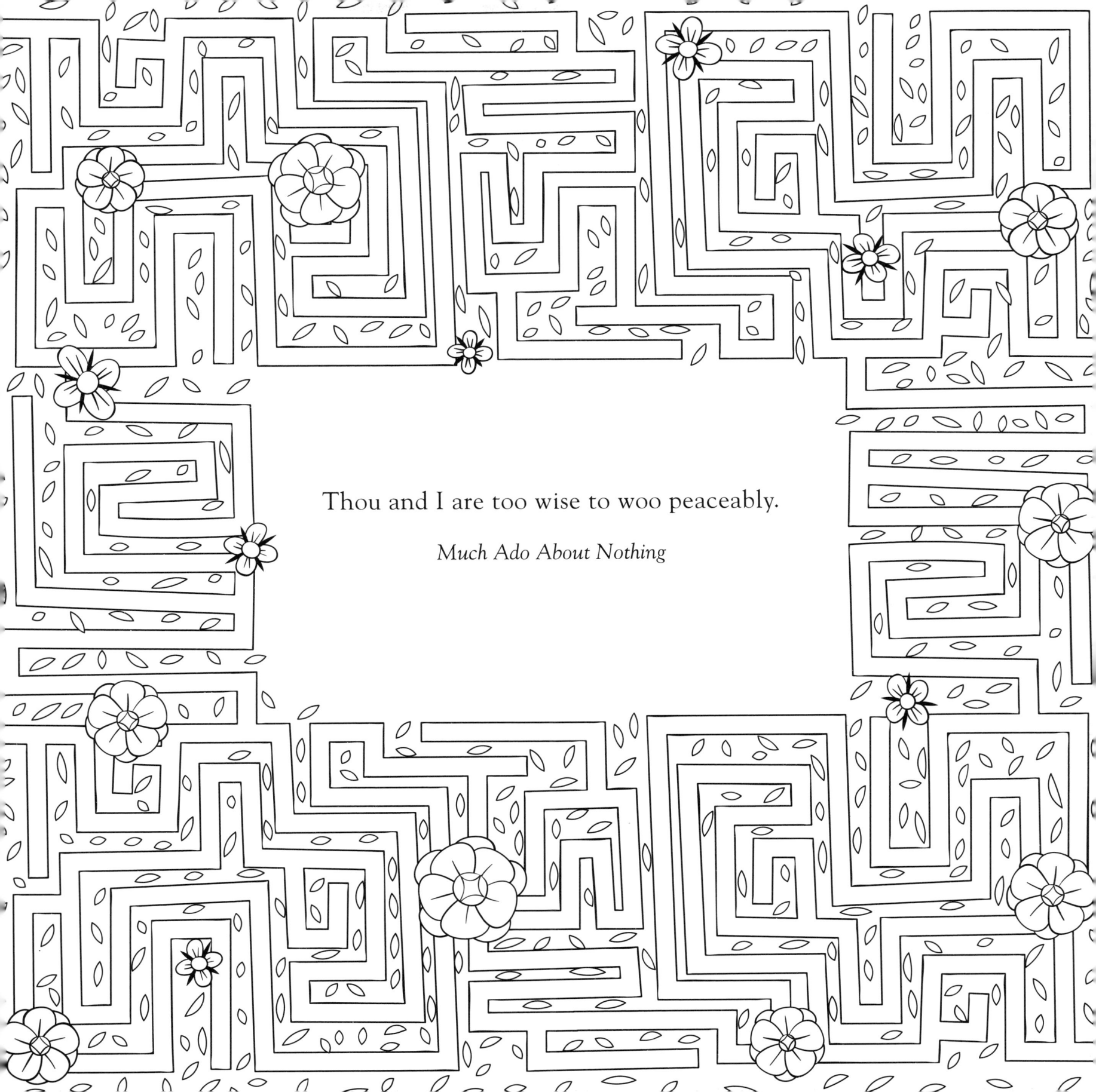

Thou and I are too wise to woo peaceably.

Much Ado About Nothing

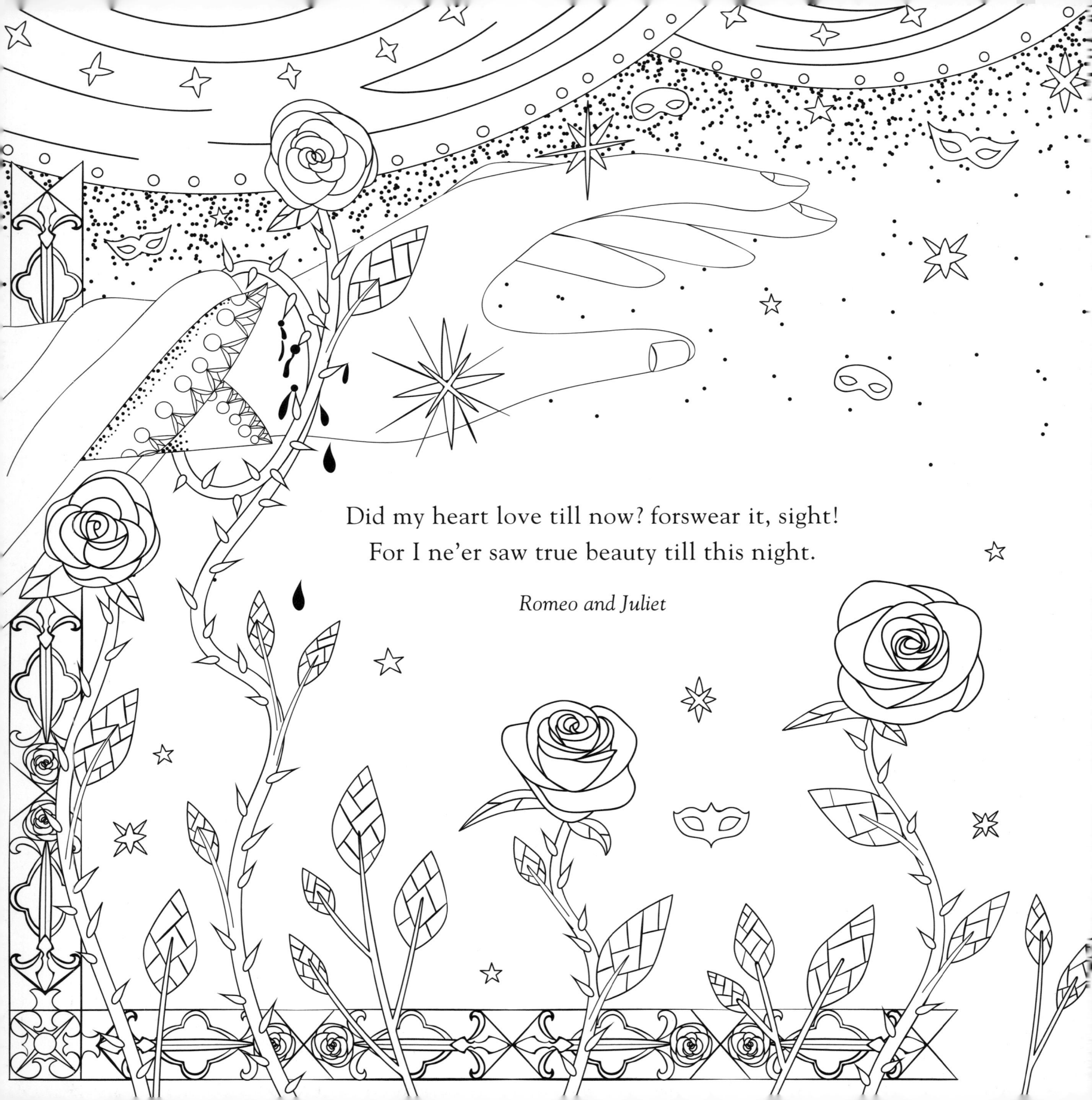

Did my heart love till now? forswear it, sight!
For I ne'er saw true beauty till this night.

Romeo and Juliet

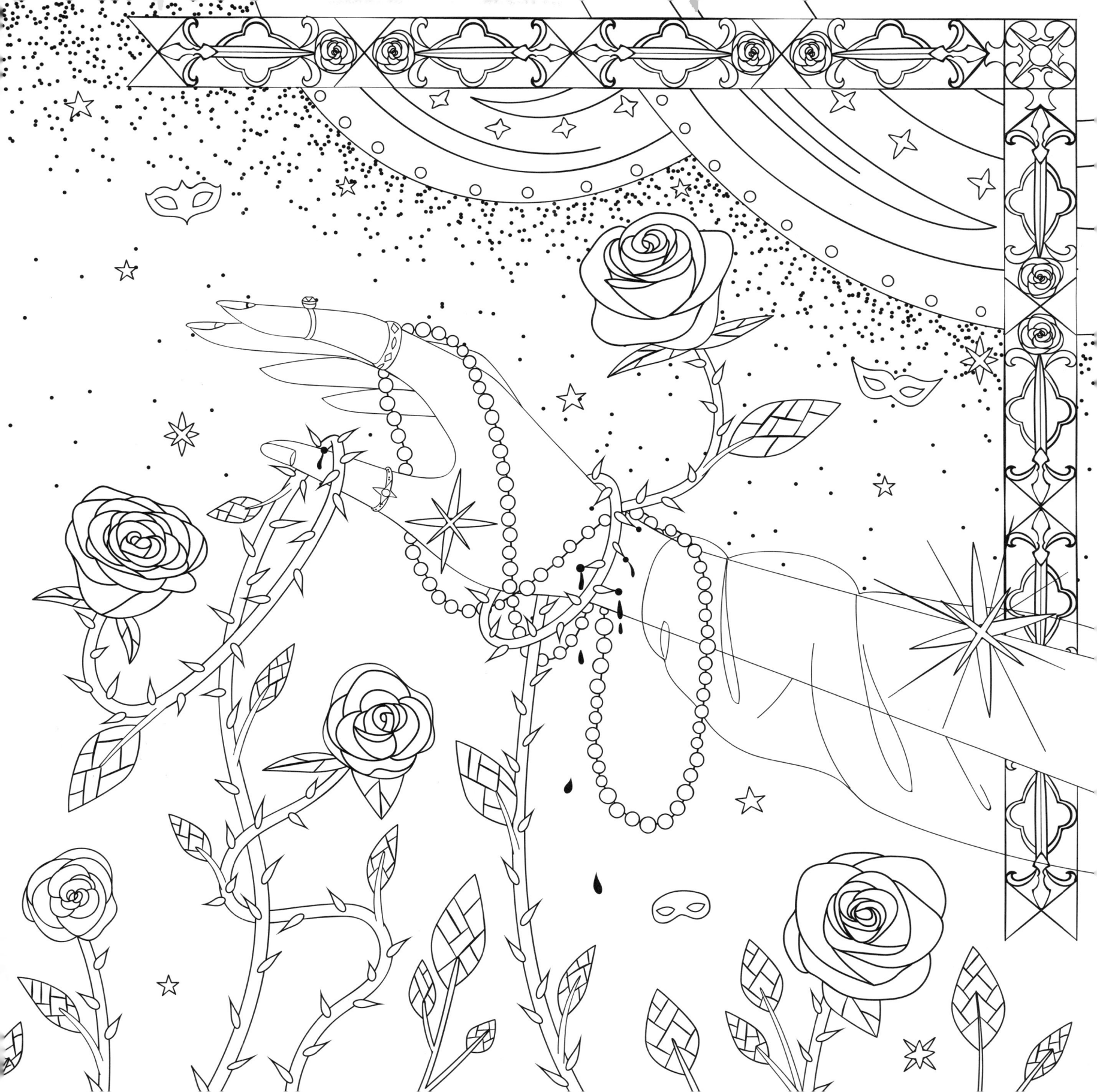

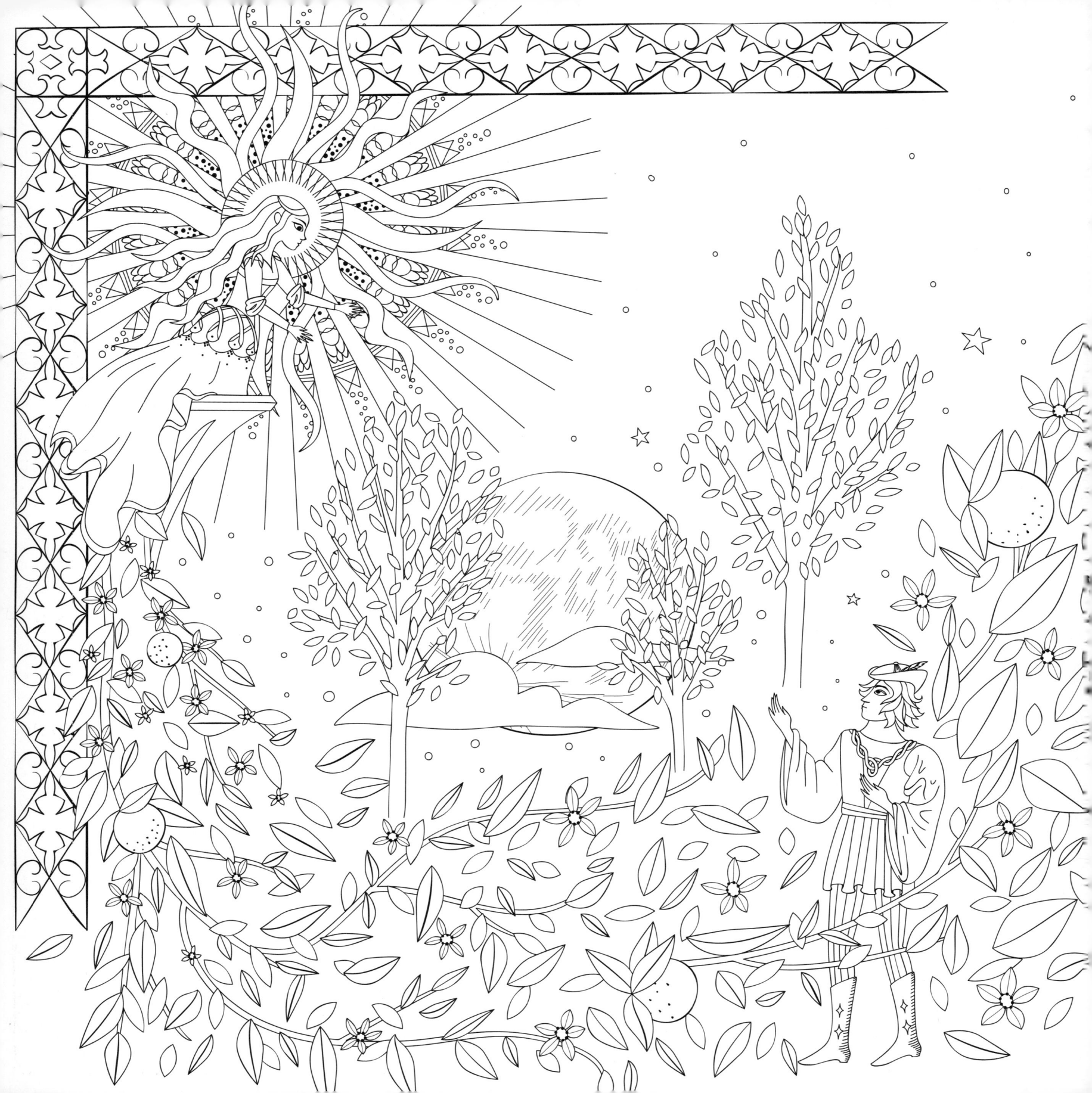

But soft!
What light through yonder window breaks?
It is the east, and Juliet is the sun.
Arise, fair sun, and kill the envious moon,
Who is already sick and pale with grief,
That thou, her maid, art far more fair than she.

Romeo and Juliet

O happy dagger!
This is thy sheath;
there rust, and let me die.

Romeo and Juliet

I'll not budge an inch.

The Taming of the Shrew

There's small choice
in rotten apples.

The Taming of the Shrew

I see a woman may be made a fool,
If she had not a spirit to resist.

The Taming of the Shrew

Come unto these yellow sands,
And then take hands;
Curtsied when you have, and kiss'd,—
The wild waves whist,—
Foot it featly here and there;
And, sweet sprites, the burden bear.

The Tempest

We are such stuff
As dreams are made on, and our little life
Is rounded with a sleep.

The Tempest

Where the bee sucks, there suck I:
In a cowslip's bell I lie.

The Tempest

If music be the food of love, play on.

Twelfth Night

One face, one voice, one habit, and two persons,
A natural perspective, that is and is not!

Twelfth Night

And thus the whirligig of time brings in his revenges.

Twelfth Night

Injurious wasps, to feed on such sweet honey
And kill the bees that yield it with your stings!
I'll kiss each several paper for amends.

Two Gentlemen of Verona

O, how this spring of love resembleth
The uncertain glory of an April day,
Which now shows all the beauty of the sun,
And by and by a cloud takes all away!

Two Gentlemen of Verona

O heaven! Were man
But constant, he were perfect.

Two Gentlemen of Verona

How sharper than a serpent's tooth it is
To have a thankless child!

King Lear

Blow, winds, and crack your cheeks! rage! blow!

King Lear

Why should a dog, a horse, a rat, have life,
And thou no breath at all?

King Lear

Why, then the world's mine oyster.
Which I with sword will open.

The Merry Wives of Windsor

Better three hours too soon than a minute too late.

The Merry Wives of Windsor

In love the heavens themselves do guide the state;
Money buys lands, and wives are sold by fate.

The Merry Wives of Windsor

We were as twinn'd lambs that did frisk i' the sun,
And bleat the one at the other: what we changed
Was innocence for innocence; we knew not
The doctrine of ill-doing, nor dream'd
That any did.

The Winter's Tale

Exit, pursued by a bear

[Stage Direction]

The Winter's Tale

I am ashamed: does not the stone rebuke me
For being more stone than it?

The Winter's Tale

But I will wear my heart upon my sleeve
For daws to peck at: I am not what I am.

Othello

Farewell the tranquil mind! farewell content!

Othello

I kiss'd thee ere I kill'd thee: no way but this;
Killing myself, to die upon a kiss.

Othello

Fair is foul, and foul is fair:
Hover through the fog and filthy air.

Macbeth

By the pricking of my thumbs,
Something wicked this way comes.

Macbeth

Out, damned spot! out, I say!—
One: two: why, then, 'tis time
to do't.—Hell is murky!—

Macbeth

About the Author

Odessa loves botanical gardens, animals, and patterns. Whenever there's an opportunity to combine them, she's all for it! She is an illustrator and surface pattern designer currently working in Kansas City. To see what she's drawing now, follow her at instagram.com/odessabegay or check out her website www.odessabegay.com.

Acknowledgments

I want to again thank everyone at Sterling for being so supportive and great to work with, especially Marilyn Kretzer for all your belief in me.

Thank you to my agent Fran Black for being the best dressed, tallest, smartest, kindest, most fabulous agent ever.

Thank you again to the Breindels, Feldmans, Greenbergs, Mom, my good friend Mark Byrne, our good friends the Friedmans, the Gilbertos, and our friends in LA, NYC, and DC for being the ultimate personal cheerleaders. I love you all.

Thank you again to my husband Jordan!

And thank you most of all to everyone who has enjoyed my previous books. ☺